DIRECTOR'S CHOICE
CALOUSTE GULBENKIAN MUSEUM

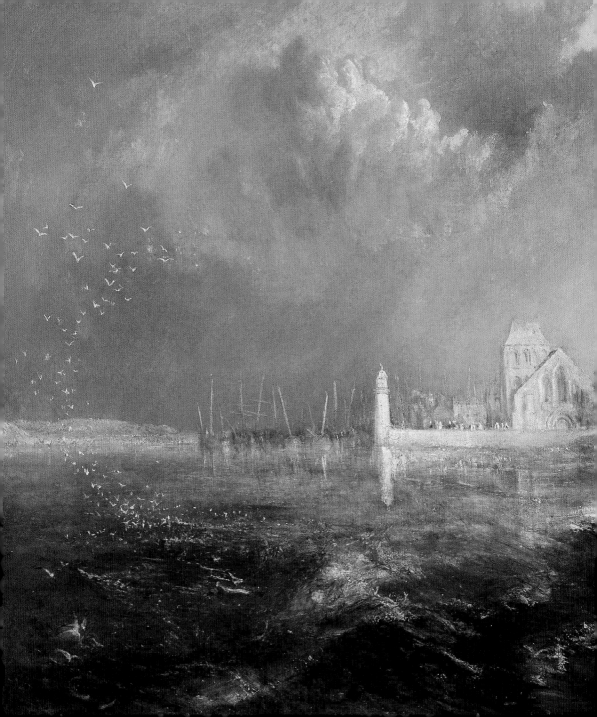

CALOUSTE GULBENKIAN MUSEUM

António Filipe Pimentel

SCALA

INTRODUCTION

IF I REMEMBER CORRECTLY, I was 13 years old when I first set foot inside the extraordinary oasis that the Calouste Gulbenkian Foundation represents. For reasons that I cannot fathom now, I was alone on that summer's day. I recall only disconnected flashes, but the images themselves are crystal clear in my memory: the wondrous garden, with its loose, serpentine landscaping; the incredible luxury of an ocean of cream carpet, my footsteps marooned on its vast expanse; the interior of this curiously welcoming, captivating building; and, most strikingly of all, the museum itself.

Like a film playing out, that visit imprinted a succession of images on my youthful mind. Some of the memories are very sharp indeed: the mysterious, shadowy Egyptian Room, the sea of carpets in the Gallery of Islamic Art, the rooms dedicated to China and Japan, the exquisite French silversmithing, the paintings by Guardi, the Lalique Room, and the ever-present views of the gardens everywhere I went, complementing the works on display. Those impressions seared themselves onto my retinas and onto my teenage mind. I retained a number of powerful images: Rodin's *Burgher* emerging from the bushes at the entrance to the building; the blue splendour of *Monsieur de l'Épinoy*; the radiant eroticism of *Diana* (whose nudity caused a scandal in the 1775 Salon).

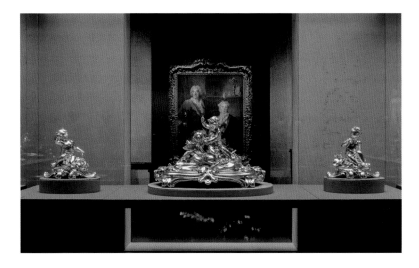

Room containing French silver from the 18th century.

Chinese and Japanese Gallery.

Back then, of course, the major episodes in the collection's illustrious history rather passed me by: both the triumphs (like the remarkable wealth of acquisitions from the Soviet government in 1930, including the Rembrandts, the Rubens, silver pieces by Germain, and the *Diana*) and the tragedies (like the devastation caused by the flooding of 1967, when the collection had arrived in Portugal and the museum was being prepared to host it). Above all, I could not have foreseen that decades later I would be entering this place as director, tasked in that capacity with the challenge of selecting my personal choice of just 37 from a collection of over 6,000 works, assembled according to the most exacting criteria of beauty, state of preservation and provenance.

How does one possibly rise to such a challenge, given the practical impossibility of covering all of the areas of the museum? Well, here are my choices, such as they are. Alas, I have had to omit major areas, like the extraordinary collection of Iznik ceramics (one of the Foundation's great glories) and exceptional works like Rubens's remarkable *Hélène Fourment*. The book arts, one of Calouste Gulbenkian's great passions, are also omitted here, but I could not resist including a couple of drawings to highlight one area of this art that tends to be hidden by its very nature, while also giving a nod to the pieces that made such an impression on me in my youth.

My selection is presented in an order that reflects the route that visitors take through the museum and seeks to replicate for the reader my own experience and feeling of discovery. Along the way, I have also attempted to capture Calouste Gulbenkian's complex personality, which is key to understanding his collection, its sheer abundance being testament to a lifetime of meticulous work. I hope that you have a wonderful visit.

Head of Senwosret III

Egypt, 12th Dynasty, *c.*1860 BC

Obsidian, 12 cm

Inv. 138

THE CALOUSTE GULBENKIAN MUSEUM opens onto a small room, where the finest of just over 50 works are displayed in a dimly lit, mastaba-like setting, illustrating the collector's fascination with ancient Egypt. This exquisite set of pieces was collected between 1907 and 1942, with Gulbenkian declaring himself 'eager to possess only the very best'. Among them is this small sculpture, a fragment of a full-length statue of the great pharaoh of the Twelfth Dynasty. Astonishingly, it is carved in very hard obsidian, a volcanic rock similar to glass (and equally fragile), brought from distant Ethiopia through Nubia.

Despite the diminutive scale of the piece, the artist knew how to create an image of strength and power and convey the mythical aura that would surround the monarch's very long reign for centuries later, denoted here by the pleated headdress (*nemes*) and the sacred serpent (uraeus), the symbol of royal dignity. Arguably, it exudes an evocative, seductive power that is unmatched within the room. Certainly, no other piece seems to have given Gulbenkian such keen pleasure to add to his collection as this one, which he would describe as 'undoubtedly the most beautiful work of art ever to have come out of Egypt'.

The extraordinary MacGregor Collection from which the piece came was reputed to be one of the most remarkable ever to have been assembled. The auction, held in London in the summer of 1922, saw the sale of around 9,000 objects organised into 1,800 individual lots. Yet among this multitude of pieces, the *Head of Senwosret* would prove to be the piece that grabbed attention, and Gulbenkian paid £10,000 for the sculpture, an astronomical price never to be repeated in this area of his collection. It would, moreover, mark the beginning of Gulbenkian's relationship with Howard Carter, although it was not a factor in this specific purchase. Towards the end of that year, Carter gained worldwide renown himself for the discovery of the inviolate tomb of Tutankhamun, and would go on to become Gulbenkian's special adviser in the field of Egyptian antiquities. For that reason, too, the head is a unique piece.

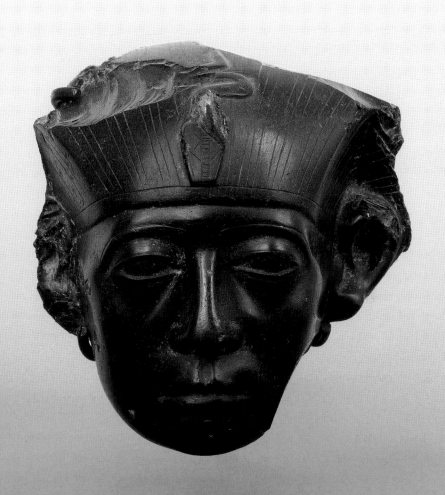

Bas relief

Assyria, Nimrud, 9th century BC

Alabaster, 230 × 140 cm

Inv. 118

'AS YOU ARE NO DOUBT AWARE apart from painting I am also interested in sculpture, antiques and many other things,' Gulbenkian wrote to the American dealer George Davey in 1942. This wide-ranging interest was reflected in the inclusion of what may be the smallest section of the collection: Mesopotamian art. It was, however, important enough for the 'Assyrian Room' (which also housed Egyptian antiquities) to be considered the 'most important room in the house' at Gulbenkian's mansion in Paris, the famous 51 avenue d'Iéna.

This imposing bas-relief from the Northwest Palace of ancient Kahlu (now Nimrud), built by Ashurnasirpal II (883–859 BC), sparked a taste for covering the lower part of the walls of public rooms with large figurative slabs. It was originally part of a group of 200, some of which are now dispersed around European and American museums. Unfortunately, those that remained in situ were recently destroyed by the self-proclaimed Islamic State (ISIS).

The large alabaster relief, in a style that places it in the Neo-Assyrian period, was acquired in Paris in 1920. It appears to depict a winged genie (*apkallu*), with his right hand raised in a ritual gesture and his left hand carrying a situla for holding sacred water, and was intended to protect the royal residence from misfortune. In the centre lies a long laudatory inscription in cuneiform characters, proclaiming the achievements of the sovereign. The austere, abstract style distances this work from the informal spontaneity of reliefs dedicated to military or hunting themes, and it is an excellent example of the quality that Assyrian artists achieved in the art of bas-relief, their greatest and most original form of expression.

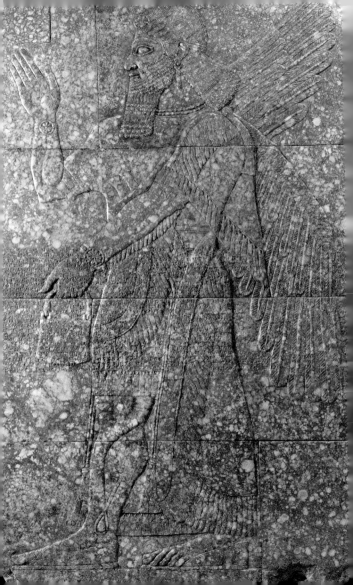

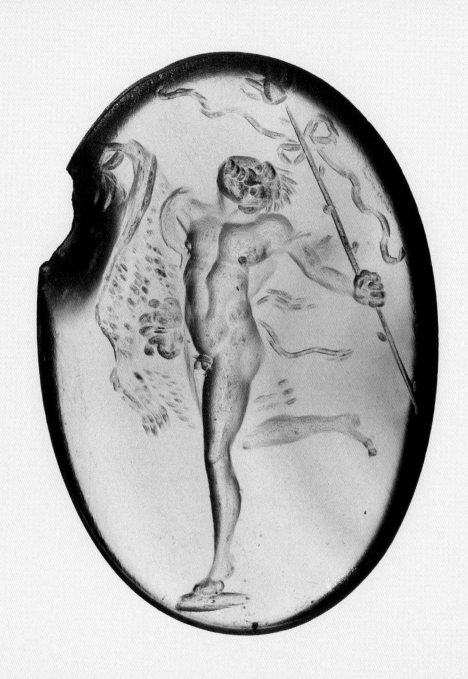

Roman gem
Roman, 1st century AD

Carnelian, 1.92 × 1.32 × 0.37 cm

Inv. 2760

ACQUIRED IN LONDON in 1898 from the former Alfred Morrison Collection, this gem depicts a naked, dancing satyr with a lion skin draped over his right arm and a drinking cup in his right hand. His left holds a thyrsus (symbolic staff) adorned with a fluttering ribbon. This motif derives from a Greek prototype and was a popular theme in Roman decorative arts, particularly on gemstones. A sense of movement is evoked by the bold positioning of the legs and the head thrown sharply back.

Subtly carved in carnelian, this gem is typical of Gulbenkian's early purchases, alongside the oriental carpets, Greek coins and Lalique jewellery that form the solid base of the collection. The number of gems and cameos is comparatively small, but it does include superb specimens from collections that have since been scattered, such as those of the Duke of Marlborough, Horace Walpole, Francis Cook and Alfred Morrison, which previously included this piece.

Indeed, this subject would continue to interest Gulbenkian until at least 1925, as is evident from repeated acquisitions as he endeavoured to gather the most significant catalogues relating to the genre in his library. In keeping with his customary modus operandi as a collector, these acquisitions were usually discreetly brokered by Armenian agents.

Besides the splendour of the materials and mountings, which turned these gems into jewels, Gulbenkian also appreciated the classical aesthetic, which is present in so many aspects of his collection. He clearly also admired the artifice of sculpture in miniature and sought it out in numismatic pieces too. Ultimately, he was looking for beauty, the great common denominator of the collection that he would go on to amass. And that is certainly present in this splendid figure, subtly carved into the tiny semi-precious stone.

Aboukir medallion

Central Eastern Roman Empire, 3rd century AD

Gold, 54 mm diameter

Inv. 2428

IN A LETTER IN 1946 TO LUCIEN NAVILLE, a renowned numismatist and dealer in ancient coins, Gulbenkian wrote: 'I must confess that I do not just collect rare coins; first and foremost, I collect coins that combine rarity with great artistic value and a perfect state of preservation; they must look as though they never went into circulation.' In keeping with his guiding principle of acquiring 'only the best', he would go on to assemble a remarkable collection of more than 1,500 specimens that are emblematic of the Hellenic world. The collection is universally considered one of the most important to be held by a private individual. The remarkable, enigmatic set of gold medallions discovered in the Egyptian town of Aboukir in 1902 is a slightly different case, as these are the only surviving specimens from the Roman period to feature a particular set of characteristics. Of the 20 medallions found at the time, Gulbenkian acquired a total of 11, the last in 1949. As a result, the museum in Lisbon is now the main repository of these extraordinary pieces.

Their precise purpose is unknown, as they are not based on a defined type of coinage, have different weights and, most significantly of all, do not derive from any official Roman currency. What they have in common is their Greek lettering, as opposed to Latin, and their relationship with the mythography of Alexander the Great (352–323 BC), testifying to the esteem in which the great conqueror was held during the Roman period. Accordingly, Caracalla, known for his fanatical emulation of Alexander, is the only Roman emperor depicted here.

This medallion is certainly one of the most beautiful in the set. On the obverse, it bears an idealised portrait of Alexander, already deified, his brow adorned with a diadem and a ram's horn, the symbol of the Egyptian god Amun. The reverse shows a hunting scene in which a wild boar is being pursued by two dogs and is struck by the hunter's spear. The hunter is identified by a Greek caption that reads 'King Alexander'.

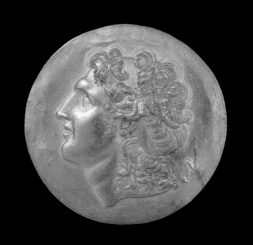

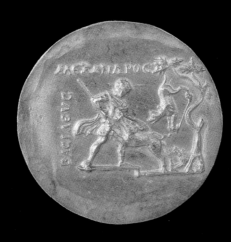

Mosque lamp

Egypt or Syria, Mamluk period, 14th century (after 1321)

Gilded and enamelled glass, 31 cm (height) × 20.5 cm (diameter)

Inv. 1033

'ALLAH IS THE LIGHT OF THE HEAVENS AND THE EARTH; the likeness of His Light is as a wick-holder.' This passage from the Verse of Light in the Qur'an undoubtedly inspired the extraordinary quantity and quality of lamps produced in the Islamic world. These were made in a range of materials, especially precious metals, and were intended for religious or funerary purposes. Large, lavish and elegantly shaped glass lamps were produced at the behest of the Mamluk dynasty of Egypt during the fourteenth century. Gulbenkian would acquire a significant number of these pieces. These pieces were notable for their imposing scale, gilding, enamel work, elegant vase shape and beautiful calligraphic decoration. When lit, they shone resplendently, the very embodiment of the Quranic verse, and they were also emblazoned with the name of the sultan or emir who commissioned the piece.

In the mid-nineteenth century, such lamps were collected all over Europe with such enthusiasm that they became something of a rarity in their place of origin. This lamp, one of the most exquisite creations from the Mamluk period, is a prime example of this phenomenon. Made after 1321 at the behest of the emir Ali ibn Baktamur for the mausoleum of Ala al-Din, as attested by the inscription on the bulge, it later formed part of the collection of Baron Gustave de Rothschild (1829–1911) before being bought by Calouste Gulbenkian in late 1919. It appeared in the famous book *Recueil de dessins pour l'art et l'industrie* (1859), inspiring French glassmaker Philippe-Joseph Brocard to reproduce it using medieval Islamic techniques. It was subsequently displayed at the Exposition Universelle in Paris in 1867, where it gave rise to countless copies, with minor variations.

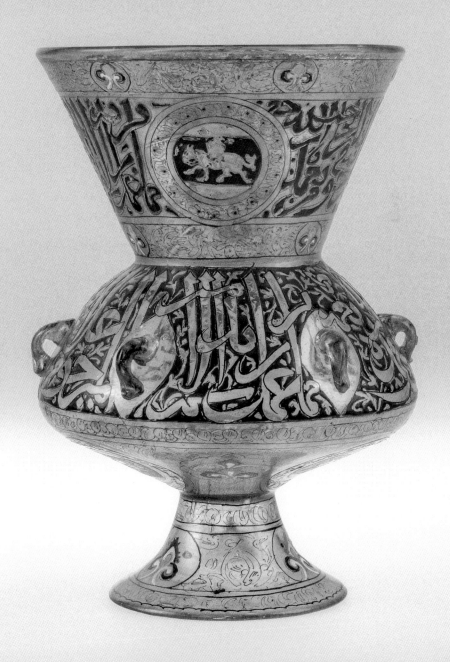

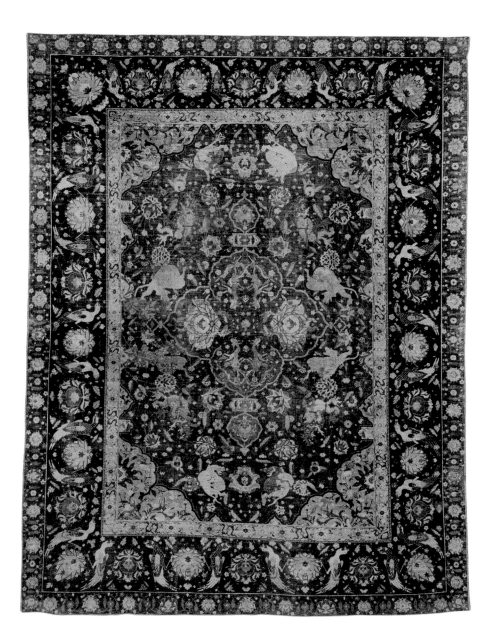

'Animal fighting' carpet
Persia, Kashan, Safavid period, 16th century

Silk, 230 × 180 cm
Inv. T100

DESPITE A LACK OF SOURCES to substantiate a link between Calouste Gulbenkian's penchant for collecting carpets and his family's (and indeed his own) involvement in the carpet trade, his passion for such pieces is undeniable. Although he had acquired no more than 15 carpets by 1920, in the period leading up to 1939, he bought around 50 of these 'classic historical pieces'. This is what prompted him to start calling himself a collector. In his book *La Transcaucasie et la Péninsule d'Apchéron* (1891), he dedicates an entire chapter to oriental carpets. This publication serves not only as a layperson's guide to the art, but also a miniature treatise on cultural anthropology and a defence of what he calls 'art comparable to any of the plastic arts'.

This conviction comes to the fore when he writes about Persian silk carpets, the production of which is slow and painstaking. These, he claimed, were 'masterpieces that take several years to make. Prices of such items can well compare to those of famous paintings.' All this suggests that this carpet, which features a scene of fighting animals, would have held particular significance in the collection.

Acquired in 1936 from the Kunstgewerbemuseum in Berlin, it had previously belonged to Wilhelm von Bode. It was produced in Persia (perhaps in Kashan, renowned for its silk carpets) in the sixteenth century, probably during the reign of Shah Tahmasp I of the Safavid dynasty. It is entirely and sumptuously woven in silk (warp, weft and pile), with the high density of knots allowing for an immensely detailed design. It is part of a group of 16 luxury products intended for monarchs or use at court. They are thought to have originated from the same place because of certain similarities in the decoration, which in this case is particularly rich and complex.

Anthology of Sultan Iskandar

Iran, Shiraz, Timurid period, 1411
Calligraphy: Mahmud ibn Murtaza al-Husayni and Hasan al-Hafiz
Opaque watercolour, ink and gold on paper, 27.4 × 17.2 cm
Inv. LA161, vol. 1, fols 028r–027v

THIS VALUABLE ILLUMINATED CODEX, created in ink, gold and opaque watercolour on paper, joined the collection not as the result of an acquisition, but as a donation from Baron Edmund de Rothschild to Calouste Gulbenkian in around 1923. Gulbenkian considered it his most beautiful manuscript, and it was undoubtedly one of the best examples of book art from the Timurid dynasty (1378–1506). It was the work of the calligraphers Mahmud ben Ahmad al-Hafiz al-Husseini and Hassan al-Hafiz.

Iskandar (1384–1415) was the grandson of Timur (or Tamerlane), the founder of the Timurid Empire, and one of his dynasty. After Timur's death in 1405, the members of this dynasty shared out an immense area between themselves, stretching from eastern Iran to Central Asia. At the time the manuscript was produced, Iskandar was governor of Shiraz. In addition to an illustrated horoscope (currently in London) and a collection of scientific texts (now in Istanbul), the Anthology included the two volumes held at the Calouste Gulbenkian Museum. One was a collection of poetic texts and the other of prose. They included 38 miniatures and 15 full-page or half-page decorative illuminations.

Three years after the Anthology was made, the Sultan was executed on the orders of Shah Ruhk, his uncle, against whom he had rebelled. He was 31 years old. Despite his tender age, his role as a patron would have a lasting impact on Persian book arts; some 70 complete and incomplete manuscripts are associated with him.

His interest in anthologies would also be reflected in the large number of works of this kind produced over subsequent years.

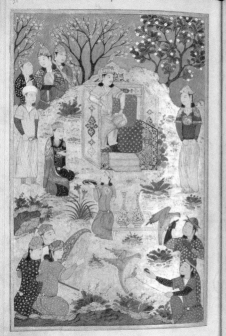
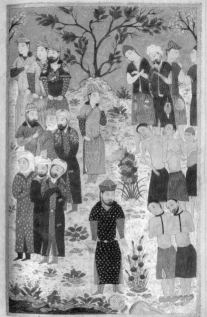

Jug

White jade (nephrite)

Central Asia, Samarkand

Timurid period, 1417–49

14.5 (height) × 16 cm (diameter)

Inv. 328

This jug (*mashraba*) is carved from white jade (nephrite), which originates from the Kunlun Mountains east of Samarkand in the present-day Chinese province of Xinjiang. Its unquestionable beauty and rich history make it one of the most famous pieces of Timurid art. The jug was made in Samarkand, the capital of the Turkestan and Transoxiana regions of Central Asia, between 1447 and 1449, in the court workshops during the reign of Ulugh Beg. This is attested to by its exceptional quality, large size and the magnificent milky hue of the jade. The legend on the neck bears the name and titles of Ulugh Beg, son of Shah Rukh and grandson of Timur, along with the phrase 'May the rule of the king and sultan be eternal', thus linking the execution of the piece to the precise period of his reign.

Although Ulugh Beg assumed the crown upon the death of his father (a member of the Timurid dynasty, between whom the vast empire assembled by his grandfather Timur, or Tamerlane, was divided), he was effectively the ruler from 1409 and was able to exercise his illustrious patronage to the full, particularly with regard to objects made of precious materials. The splendid jug later made its way to India, as evidenced by later inscriptions referring to the Mughal emperor Jahangir (whose name and titles were added to the rim in 1613) and his successor, Shah Jahan (whose name and titles can be read beneath the handle). Both sovereigns clearly sought to appropriate its symbolic value. The dragon on the handle, topped by a floral ornament, reflects the influence of Chinese art on the Samarkand region.

Given Gulbenkian's ongoing obsession with pieces that met his exacting requirements of beauty, provenance and state of preservation, he must have been delighted to acquire this extraordinary jug in London in 1927.

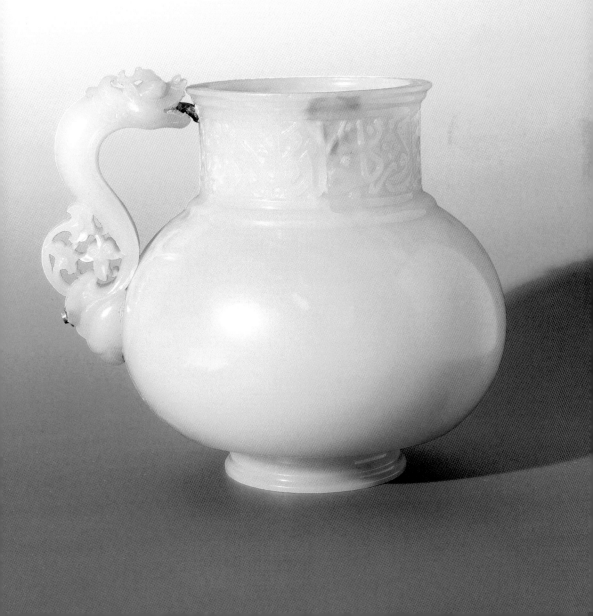

Illuminated bible

Constantinople, 1623

Paper and vellum, 22.4 × 16.5 cm

Inv. LA152, fols 13–14

OVER THE CENTURIES the Armenian Church would inform the spiritual, cultural and political character of Armenian communities. Over time this religious and cultural legacy acquired its own separate identity within an aesthetic framework in which Persian, Byzantine and Syrian influences intersected. This was especially apparent in the book arts. The art of illumination flourished among Armenian communities established in Constantinople, the Crimea and Isfahan from as early as the seventeenth century. For the first time, wealthy Armenians began commissioning bibles that were extensively illuminated with images inspired by traditional manuscripts or printed books from Europe.

This is one such bible, acquired in London in 1926 at the sale of Sir Malcolm MacGregor's collection. It was commissioned by a wealthy Armenian merchant from the community of New Julfa in Persia, made in Constantinople (present-day Istanbul) by a copyist named Hakob, and completed in 1623, as inscribed in the main colophon according to Armenian tradition.

New Julfa was a district of Isfahan where members of the Eastern Armenian community settled in 1603 following the conflict between Iran and Turkey. They named the area after their native city of Julfa. Although there were plenty of workshops for copyists and illuminators, this particular book was commissioned to be made in the ancient Byzantine capital. This may have been due to the complexity and richness of the manuscript, as evidenced by the frontispiece of the Old Testament, illustrating the six days of the creation of the world, represented in the side medallions. The central area, on a golden background, depicts the creation of Adam and Eve, the scene of the temptation and the expulsion from Paradise. It is no wonder, then, that the arrival of these bibles in New Julfa instantly sparked a whole industry of replicas.

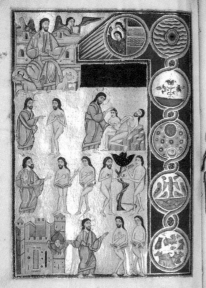

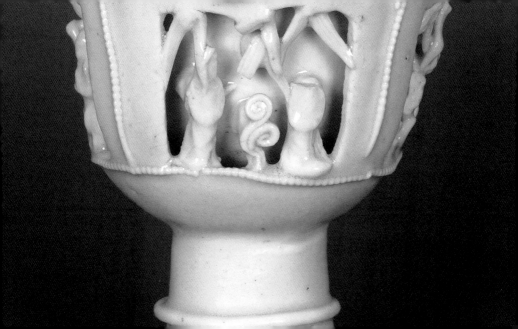

Stem cup

China, Yuan dynasty, early 14th century

Qingbai blue-glazed porcelain, 10 cm (height) × 9.5 cm (diameter)

Inv. 2372

THE COLLECTION CONTAINS MANY magnificent pieces of Chinese porcelain, especially the sumptuous pieces from Ming dynasty (1369–1644) and an abundance of works from the Qing dynasty (1644–1911), particularly from the eighteenth century, illustrating Gulbenkian's taste for eclectic exoticism, in common with the trend of European collecting in the late nineteenth and early twentieth centuries. Yet among them, a solitary jewel, is this little Qingbai ceramic cup, the sole piece from the Yuan dynasty (1279–1368). It was acquired in 1947 in London, at the sale of the Henry Brown Collection, completing a collection for which purchases were made between 1907 and 1947.

Quingbai means 'bluish-white'; the origin of these delicate, translucent pieces, made of white porcelain covered in pale blue glaze, is linked to ceramic production during the Song dynasty and the great centre of Jingdezhen, where such pieces started to be made between 907 and 960. They were the first to be called 'porcelain' and reflected the evolution of stoneware in southern China, serving as a model for future Chinese craftsmanship in this material.

Beyond its historical or emblematic value, however, it was the intrinsic beauty of this remarkable object that seduced the collector. Created as early as the fourteenth century, the little cup is covered in a bluish glaze whose translucent sheen highlights its delicate workmanship. It was fashioned using a complex double-walled technique with four cut-out panels, whose lobed edges are repeated on the inside, bordered by a fine string of tiny pearls, with miniature depictions of Taoist sages standing out in relief among bamboo leaves.

HARA YŌYŪSAI

Inrō

Japan, late 18th century – early 19th century

Lacquer on wood, mother-of-pearl and hardstones, 7.5 × 5.5 × 2.5 cm

Inv. 1364

As with Chinese porcelain, Calouste Gulbenkian's interest in Japanese art reflected the general swell of enthusiasm for the oriental arts that followed the Great Exhibitions in the final decades of the nineteenth century. In the specific case of Japan the end of the country's long isolation and the subsequent (re)discovery of its art would have an impact on Western art and spark growing demand for Japanese pieces. Prints and lacquer pieces (particularly *inrō*) were especially popular, and Calouste Gulbenkian sought to incorporate both into his collection.

Inrō were cases for carrying small objects such as personal seals or medicines. They were associated with traditional men's garments, as these had no pockets. Suspended from the wide sash of the kimono, they became a sophisticated fashion accessory thanks to the talent of Japanese craftsmen for ornamentation. Such pieces were highly popular in the Edo period (1603–1868), but the Westernisation of the elite would render them obsolete by the end of the nineteenth century, just as they gained the attention of Western collectors.

This example is especially sophisticated and complex. Made of red lacquer, with four boxes or compartments, it bears the signature of Hara Yōyūsai (1772–1845) on the base in gold-drawn letters. The entire surface of the piece is covered with a depiction of a squirrel in relief, clinging to the branches of a vine, with hanging bunches of grapes made of mother-of-pearl. Some of the leaves are fashioned in green-coloured ivory, others in *hiramaki-e* (gold-dusted paint), *kirikane* and *taka-maki-e* (new techniques for applying gold), while the craftsman used the *nashiji* technique for the inside. The piece came from the collection of Sir Trevor Lawrence and was acquired in London in late 1916.

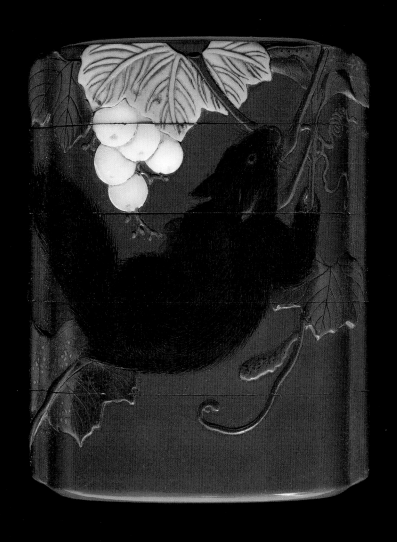

Diptych with scenes from the Life and Passion of Christ

French (Paris), *c.*1350–75

Ivory, height 26.3 cm, width 11.7 cm (each panel), 23.5 cm (open), depth 0.8 cm (each), weight 642 g

Inv. 133

GULBENKIAN'S PENCHANT FOR GOTHIC IVORIES can be traced back to his visit to the Exposition Universelle in Paris in 1900 and the *Retrospective de l'art français* held at the Petit Palais at the same time. However, a dearth of pieces on the market meant that he held back from making a purchase; only between 1914 and 1937 did he manage to assemble a small set of 11 pieces, most of which are of superb quality. This imposing diptych, acquired in 1918, is one such piece and is related to two large Passion diptychs included in the *Retrospective* of 1900.

Like Books of Hours, such diptychs or triptychs were intended to aid private devotion among the elite and were designed for easy transportation, as they could be opened and closed like books. During the period of the Black Death (1347–50) and the Hundred Years War (1337–1453) they encouraged meditation on Christ's sufferings and the expectation of redemption through his death. To appear more vivid, they were finished in colour, although this has largely disappeared from the surviving pieces.

This diptych narrates the Life and Passion of Christ in 17 episodes, arranged in chronological order from top left to bottom right – the Annunciation to Christ's Burial – within an ornamental system of delicately perforated arches. The interpretation suggested by the piece might seem obvious to viewers today, but would have seemed peculiar in the fourteenth century, when the faithful were accustomed to codified illustration of the sort found in illuminated manuscripts. This piece exhibits obvious affinities with a small group of ivories attributed to the Master of the Passion Diptych and displayed in major American and European museums. They are probably late works from the Parisian workshop active during the reigns of the French monarchs Charles V (1364–80) and Charles VI (1380–1422).

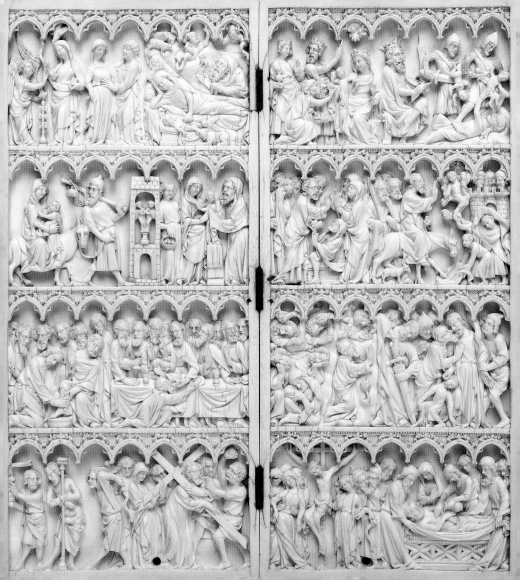

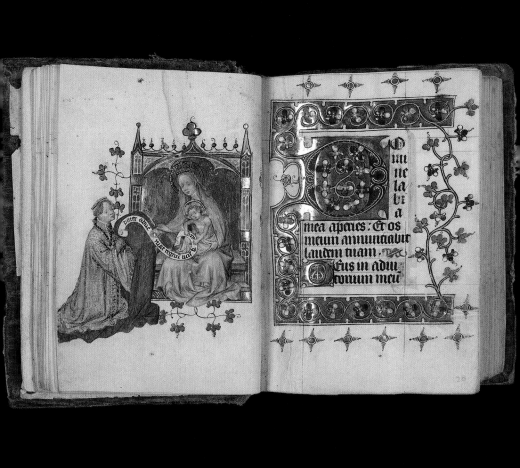

omi
ne la
bi
a
mea aperies: Et os
meum annunaabit
laudem tuam.
eus in adiu
toriium meu

Book of Hours of Margaret of Cleves

The Hague, Netherlands, *c.*1395–1400

Parchment, 13.2 × 9.6 cm

Inv. LA148, fols 19v–20r

Fol. 19v – Margaret of Cleves before the Virgin and Christ Child

AN AVID COLLECTOR OF BEAUTIFUL BOOKS, Calouste Gulbenkian also acquired a considerable number of codices and illuminated fragments, including some wonderful Books of Hours. This one belonged to Margaret of Cleves, wife of Albert I, Duke of Bavaria, whose dominions included the County of Holland and other regions of the Netherlands. Albert transformed his capital, The Hague, into a brilliant cultural centre. His court artists gained particular renown for their illuminated manuscripts and Books of Hours, which were intended for private devotion.

This codex is believed to have been illuminated in The Hague in the late fourteenth century. An inscription at the end of the Office of the Dead mentions the lady who commissioned it and her wish for the book to be preserved in her memory in the Convent of Schönensteinbach, Alsace. After passing through several owners, it was acquired by Gulbenkian in Brussels in 1924.

Its 285 folios include 11 full-page illuminations, with the subjects inscribed in frames resembling altarpieces and some images extending beyond the designated architectural structure. Although not exclusive to this Book of Hours, this visual technique adds greatly to the expressiveness and emotional impact of the scenes. The Hours of the Virgin, one of the five sections in the book, comprise a cycle of figurative miniatures. These open with an illustration of the owner, Margaret of Cleves, prostrate at the feet of the Virgin Mary and the Infant Jesus, who are enthroned in an altarpiece frame (fol. 19v). This illumination adopts the aforementioned solution of extending beyond the limits of the frame. The equivalence of figurative scale between the book's owner and the Virgin formalises an objective correlation between the two planes of representation – the human and the divine – and is an early hint of modernity.

DOMENICO GHIRLANDAIO

Portrait of a Young Woman

Florence, *c.*1485

Tempera on wood, 44 × 32 cm

Inv. 282

Acquired in 1929, this magnificent panel, painted in tempera on wood, is unquestionably one of the great jewels of the collection, despite its modest dimensions. It exemplifies both the first great chapter of European painting (the fifteenth and sixteenth centuries) and one of Gulbenkian's favourite types of art: the portrait. It is like a golden key opening the door to the Renaissance section.

The splendid figure of a young woman is drawn in a three-quarter profile, skilfully isolated against a black background. Captured with unparalleled precision, in the deliberate absence of any powerful emotion, she exudes an inner peace. Her various adornments, all of the utmost simplicity, encourage us to focus our gaze on a face that does not gaze back at us, but is rather fixed on something beyond the frame. The choice of chromatic palette illustrates this subtle austerity, which is the key to the timeless charm of the piece: the play of crimsons between the simple string of coral beads (the only ornament), the neckline and the lips; the skilful transition, in turn, to the golden tones of the hair, the skin of the face and neck, and the milky whites of the clothes.

Despite the efforts of art historians to link this portrait to the paintings by the same artist for the Sassetti Chapel in the basilica of Santa Trinità, Florence (1482/85) and, in particular, to one of the young women depicted in the scene of *Saint Francis Restoring a Child to Life*, this cannot be verified. The painting in Lisbon thus remains a something of a mystery, and it would be unwise to go any further than that.

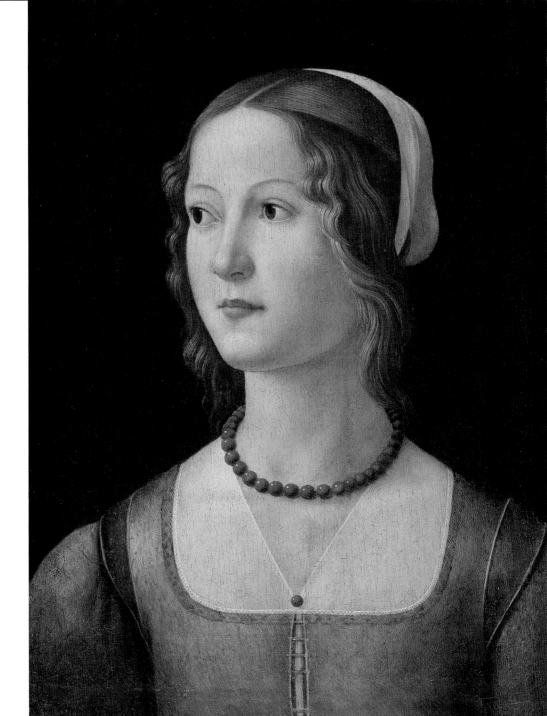

ALBRECHT DÜRER

Dead Wild Duck

Germany, *c.*1502 (?) or *c.*1512 (?)

Pen and brush, watercolour, opaque watercolour, India ink, graphite underdrawing
and gold highlights on parchment, 22.6 × 12.4 cm

Inv. 140

GULBENKIAN WAS KNOWN FOR rarely acquiring drawings; he would buy 'only those of exceptional interest and in perfect condition'. Abiding by those exacting criteria, he would collect just over 40 over the course of his life. One was this marvellous depiction of a common pochard, a type of diving duck (*Aythya ferina*) acquired in 1922. It is a splendid example of Dürer's genius in achieving a synthesis between the gothic and the Renaissance.

The duck is depicted as a hunting trophy, suspended in profile from a nail driven into the wall by a rope that runs through its nostrils, its body turned slightly to the left, its bulky mass contrasting with the distension of its neck under the weight of its body, while the shadow cast against the wall gives the whole a corporeal thickness. Despite its small dimensions, this piece, drawn with a pen and brush on parchment, with gold highlights, is unanimously considered to be one of the artist's best works based on the direct observation of nature.

While the authorship has never been in doubt, the date has been the subject of some controversy: 1502 or 1512? This is an important issue, because Dürer's second trip to Italy took place between the two dates, and because of the precedence it would (or would not) set in relation to depictions of similar themes by his contemporary Jacopo de' Barbari. Today, most critics lean towards the earlier date, with all that it implies. This transcendent work fell victim to the flooding of 1967, which did so much damage to the collection, but fortunately it was possible to restore it almost to its original splendour.

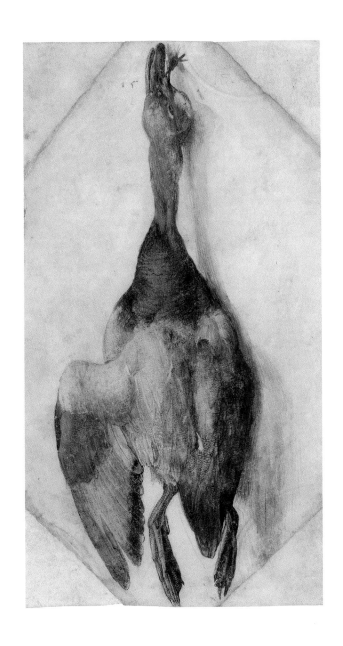

NICOLAS KARCHER, BASED ON CARTOONS BY GIULIO ROMANO

Tapestry from the series *Children Playing*

Fishing
Mantua, 1540-45

Wool, silk, gold and silver, 350 × 370 cm

Inv. 29D

CALOUSTE GULBENKIAN PURCHASED THIS almost-complete set of valuable tapestries in 1920 at the sale of the collection of the composer Albert Cahen d'Anvers. Made up of four large tapestries and two fragments, woven in wool, silk, gold and silver, the set was intended to adorn the dining room of Gulbenkian's mansion at 51, avenue d'Iéna, Paris, which was designed to house the extraordinary pieces. Four decades earlier one of the last known fragments had been acquired at an extraordinary price by the Italian collector G.G. Poldi Pezzolli and can now be seen at the Poldi Pezzolli Museum in Milan.

The association between art and artifice embodied by these wall hangings has always explained their extremely high price – much higher than equivalent paintings or sculptures. *Children Playing* was woven at Nicolas Karcher's workshop in Mantua during the period when the creator of the design, painter and architect Giulio Romano, was staying at the Gonzaga court. The fact that the artist was present to supervise the execution of the work explains the superlative quality of these remarkable tapestries, which were commissioned by Duke Federico II but completed under his brother, Cardinal Ercole Gonzaga, whose heraldry they bear.

The imposing tapestry set was inspired by one of the chapters of *Eikones* (Images) by the Hellenistic writer Philostratus the Elder, in which he describes a crowd of little cherubs (*puttini*) at play in a verdant garden. *Fishing* depicts one of their pastimes.

Enriched with realistic representations of fauna and flora and illustrated with a highly sophisticated colour palette, made even more radiant by silver and gold threads, the superb quality of the design and the brilliance of its execution make the whole piece unrivalled among the Italian tapestries of the Renaissance.

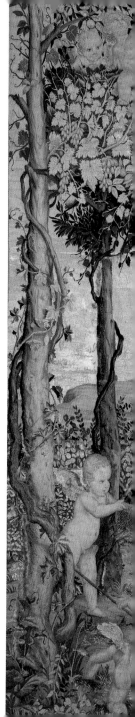

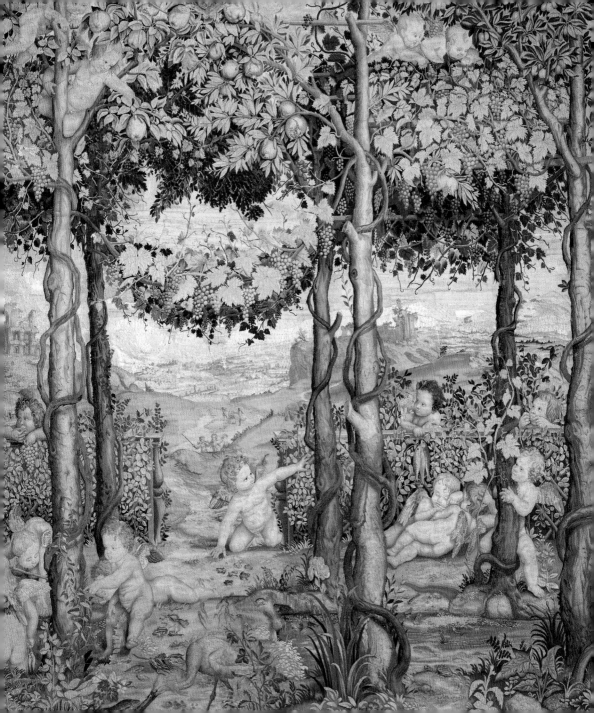

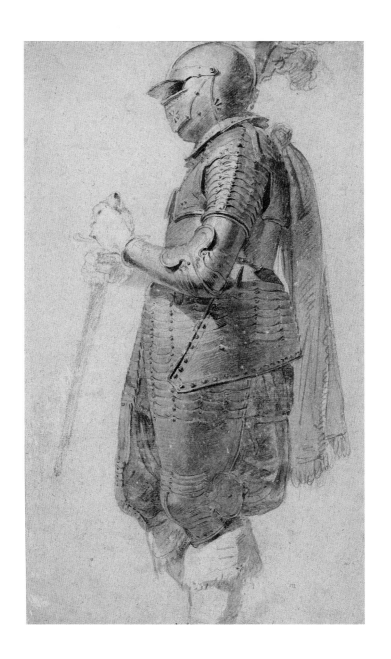

Study of Armour

Antwerp (1627–32)

Indian ink and black stone, with grey and sanguine watercolours on paper, 42.6 × 26.1 cm

Inv. 141

In 1922 Gulbenkian acquired an important drawing for his collection, the *Study of Armour* attributed to Anthony van Dyck. A year later he purchased the same artist's superb *Portrait of a Man*, which is testament to Van Dyck's acclaimed visual skill. Another seven years later, he purchased the sumptuous *Hélène Fourment* by Van Dyck's mentor Peter Paul Rubens in a famous acquisition from the Hermitage Museum.

Drawn in Indian ink and black stone, with grey and sanguine watercolours, it was one of three such drawings, all depicting the same wearer in identical armour in various attitudes. Today the other two pieces can be found at the Fogg Art Museum in Cambridge, Massachusetts. A fourth study depicting similar armour worn by a knight has also been associated with this small set; it is currently at Castle Howard, England. Another point in common is that all of the drawings originally came from the collection of Prosper Henry Lankrink (1628–92) and were all originally credited to the same artist. The study at Castle Howard was more recently attributed to Nicolas Vleughels.

As far as the Lisbon drawing is concerned, it would be fruitless to compare it to any of Van Dyck's known portraits. It is true, however, that armour is a common adornment in his work, in which he uses it to create opulent images of the aristocracy and the wealthy bourgeoisie. A superb graphic style is amply evident in the artist's work and his masterful technical ability allows him to draw out all of the visual possibilities of the armour's metallic brilliance. It is credible, therefore, that Anthony van Dyck was the artist, or that someone from his circle may have been designated to create the work. Either way, this beautiful drawing is linked to him.

Rembrandt Harmenszoon van Rijn

Old Man with a Stick
Netherlands, 1645

Oil on canvas, 128 × 112 cm

Inv. 1489

In a letter to Alexis Leger in 1950, Calouste Gulbenkian wrote about revisiting his paintings from memory: 'Of all these close friends, the most remarkable will always be the Rembrandt, which I revisit often as I had it at home, bathed in a light of wisdom capable of drawing from that admirable face an intense nobility and gentle severity.'

The Rembrandt in question was this *Portrait of an Old Man*, masterfully rendered in the artist's palette of browns, blacks and ochres, focusing the viewer's attention on the face and hands of the character, who appears to have been surprised by the painter. This was one of two works (the other being the *Pallas Athena*) by the brilliant Dutch artist that Gulbenkian acquired at the legendary sale of Hermitage paintings by the Soviet government in 1930. Among various paintings on the same theme, this is certainly the most monumental, not only in terms of its physical dimensions (which are now reduced), but because of the melancholy of that 'intense nobility and gentle austerity' that Gulbenkian would recognise in the portrait. It is the sheer physical and emotional weight of this that continues to move the viewer three centuries on. The painting was thus a worthy centrepiece of the vast and remarkable picture gallery assembled by the collector.

Although nowadays we know that this is a tronie – a study of a 'typical' human character, a genre in which the painter delighted, and thus replicable by its very nature – the 'old man', who does not return our gaze, lost as he is in his inner contemplation of Time, has the intrinsic veracity of a portrait. His wrinkles, where the painter concentrates the light, have been carved out by the life he has lived, and which the artist would now immortalise. This brilliantly captured verism makes Rembrandt a uniquely modern painter for every generation, immortalising his own genius.

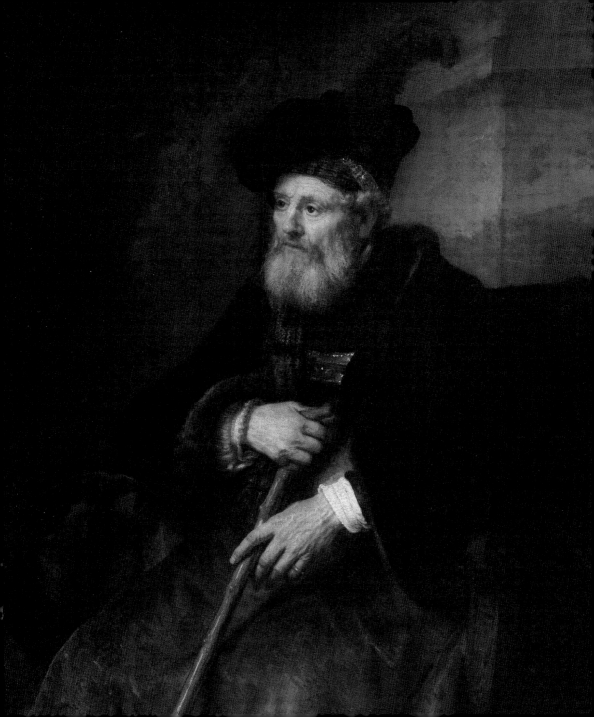

MAURICE-QUENTIN DE LA TOUR

Portrait of Duval de l'Épinoy
France, 1745

Pastel, 119.5 × 92.8 cm

Inv. 2380

IN 1943, A YEAR AFTER TAKING refuge in Lisbon at the height of the Second World War, Gulbenkian acquired from Henri de Rothschild this wonderful portrait of Louis Duval de l'Épinoy, Lord of Saint-Vrain, a former adviser and secretary to Louis XV. Given its context, it appears to be a statement of joie de vivre and the triumph of reason. As such, it makes the perfect introduction to the artistic realm of the eighteenth century, which so entranced the collector.

Executed with virtuoso skill in the delicate and complex pastel technique, applied with supreme prowess due to the large dimensions of the support, the composition was much celebrated at the 1745 Paris Salon, where it was presented ('le roy des portraits de La Tour ou le triomphe de la peinture au pastel'). Although he is a little-known figure today, the gaze captures the shrewd vivacity of Duval de l'Épinoy, who appears to have been surprised amid the luxurious intimacy of his office. The setting features allusions to geography, literature and, in general, to the cosmopolitan and refined atmosphere of the Age of Enlightenment. A preparatory study, an oil copy and another version, possibly created in the artist's own studio, are also known to exist.

The astute arrangement of volume and space and the skilful distribution of light emphasise the splendour of the chromatic palette of blues, greys and pinks. In turn, this underlines the analytical realism of the composition, expressed in the psychological rendering of the character and in the ornamental details themselves (such as the strikingly mundane note of the snuffbox).

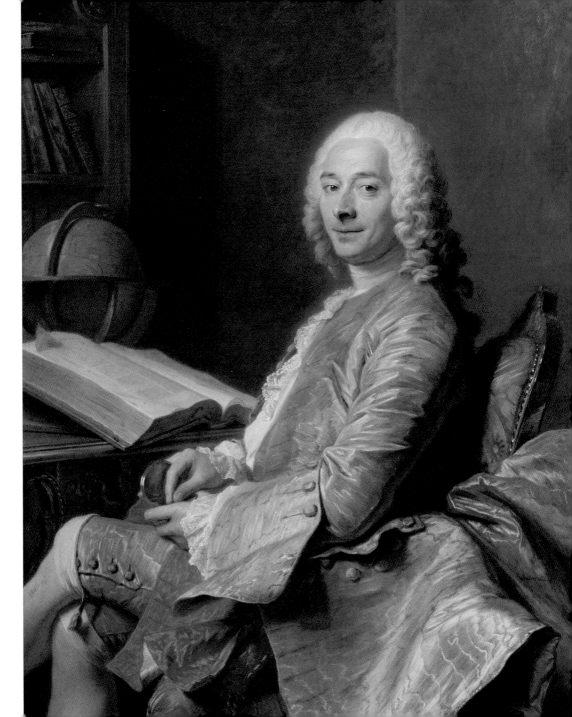

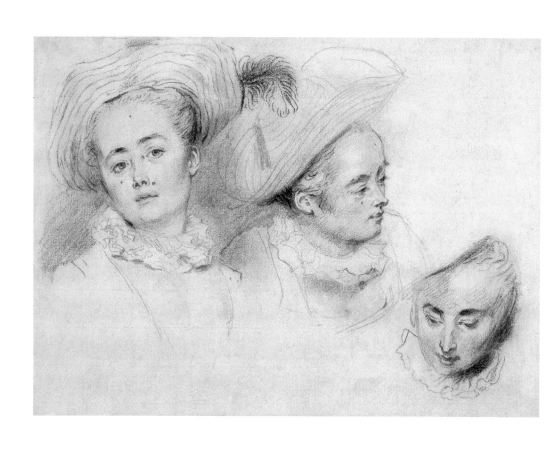

JEAN-ANTOINE WATTEAU

Three Studies of a Young Woman's Head
France, *c.*1716-17

Trois crayons (black, sanguine and white chalk) with stump on paper, 23.2 × 31 cm

Inv. 2300

THREE REMARKABLE WORKS IN THE Calouste Gulbenkian Collection illustrate the artistic personality of Watteau, one of the greatest geniuses of French rococo painting, whose meteoric career and early death at the age of 37 left a powerful impression on his contemporaries. These pieces comprise: a small portrait (the collector's first acquisition, in 1921); the two precious volumes of the album of engravings of his work by the best artists of his time in a major tribute to the artist compiled by his friend and protector Jean de Jullienne and printed in 1735; and this splendid drawing, *Three Studies of a Young Woman's Head*, purchased in 1937.

Despite his reputation as a tormented genius, Watteau was renowned for his depictions of *fêtes galantes* (dreamlike depictions of aristocrats at play in exquisite parkland settings). In drawing, Watteau found the compositional freedom that he did not believe came so readily to him in painting. He would draw without any specific objective in mind for the pure pleasure that these 'sanguine thoughts', as he called them, gave him. This drawing features three *prises de vue* of the head and shoulders of the same unknown female subject, wearing a feathered hat and frilled collar and displaying different moods. The beauty of the composition, which is harmoniously arranged on the paper, comes from the wise use of the *trois crayons* technique (black, sanguine and white chalk), which accentuates the volumes with the slant of the strokes, and the smoky effect, suggesting a soft, luminous atmosphere.

The work shows the artist at his full maturity, having been created around the same time as the famous *Embarkation for Cythera*, which guaranteed him admission to the French Royal Academy in 1717. It completely fulfils the imperative of 'exceptional interest and perfect condition' that Gulbenkian would place on the art of drawing.

JEAN DESFORGES

Commode
Paris, *c.*1750

Oak, exotic woods, lacquer, bronze and marble, 90 × 130 × 60 cm

Inv. 284

IN 1921 GULBENKIAN ACQUIRED this extraordinary piece of furniture, a paradigmatic example of cabinetmaking and the splendour of the French decorative arts of the eighteenth century in general. He would go on to assemble a remarkable collection of such pieces. Made of oak and ebony, with a marble top and rich gilded bronze appliqués, it is remarkable for its use of precious seventeenth-century Japanese lacquer panels. It was made by Jean Desforges, a cabinetmaker and ébéniste renowned for his work between 1737 and 1757. Desforges specialised in elaborate commodes and corner cupboards with lacquer panels from China and Japan, whose rarity (reflected in their extremely high cost) made these pieces of furniture products of refined luxury, aimed at an exacting and sophisticated clientele.

This opulent commode is a case in point and is reputed to be one of his finest pieces in existence. Its lavish ornamentation, in a deliberate rocaille revival that reflects the intention behind its creation, gives it a certain affinity with the works of Germain or Meissonnier. Entirely covered in antique lacquer panels adorned with gilded motifs in relief on a black background, the heterogeneity of the original panels is skilfully muted by the effect of the sumptuous gilded bronze appliqués that frame them, in a lavish play of asymmetrical curves and counter-curves that envelop this splendid piece of furniture. The same approach is evident in the ingenious solution devised for the lock on the lower drawer, with an ornate entrance that extends from the apron to the top, uniting the two panels, where the subtle play of the bronze appliqués on the gilded reliefs creates a deliberately ambiguous effect.

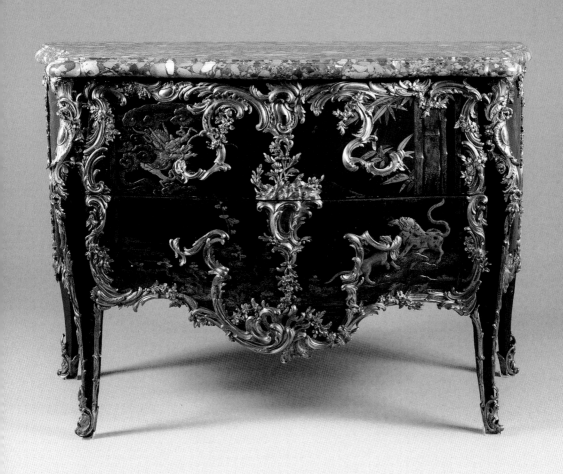

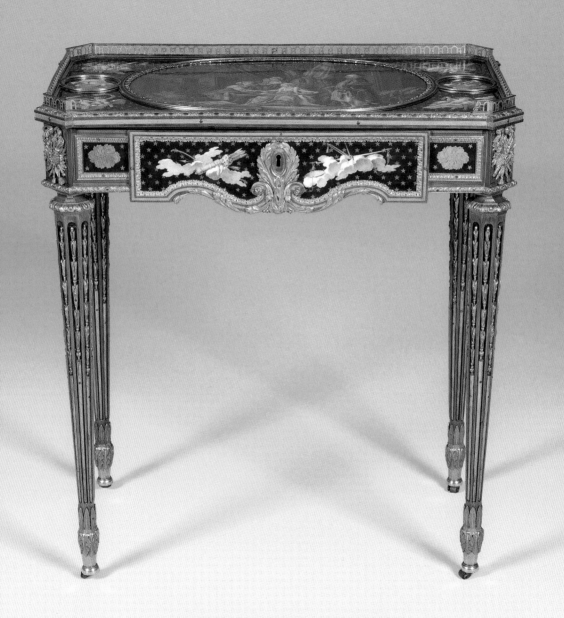

CHARLES-NICOLAS DODIN
MARTIN CARLIN

Writing table
Paris, *c.*1772

Structure in oak, veneered and inlaid with sycamore, satinwood, ebony and boxwood;
Sèvres porcelain plaques; mounting in chiselled, gilded bronze; velvet, 73 × 67 × 39 cm
Inv. 2267

UNQUESTIONABLY one of the key pieces in Calouste Gulbenkian's collection of French decorative arts, both for its significance and its rich and complex history, this extremely valuable piece of furniture was acquired by the collector in Paris in 1935. It is a small writing table for ladies, in the Louis XVI style, made of precious woods, richly decorated with gilded bronze appliqués that frame painted plaques of Sèvres porcelain. A real feast for the eyes, it would pass through a succession of illustrious owners: from its original owner, Madame du Barry, to Marie Antoinette, who gave it to her sister, Maria Carolina (both of whom had their portraits taken next to it, in a curious figurative osmosis), thus moving it from Versailles to the Neapolitan royal residence.

Designed by the cabinetmaker Martin Carlin, its particular charm comes from the 20 porcelain plaques on its top and sides, finely framed in gilded bronze. The large, oval-shaped plaque at the centre reproduces the engraving *The Russian Fortune Teller* by René Gaillard, based on the painting *La Bonne Aventure*, which Jean-Baptiste Le Prince exhibited at the Salon in 1767. Signed by Charles-Nicolas Dodin and dated 1771, this opulently coloured plaque commanded a very high price, indicative of its intended clientele. It is surrounded by other plaques, predominantly featuring a grid of gold stars against a background of exquisite *bleu du roi*, which would go on to make the fortune of those producing Sèvres pieces. The theme reflects the Enlightenment taste for the exotic, echoed in the astrological elements that adorn the peripheral plates.

ATTRIBUTED TO JUSTE-AURÈLE MEISSONNIER

Ewer in jasper with gold mount

Ewer: Paris (?), 14th century (?)

Mount: Paris, 1734–35

Jasper and gold, 33.5 cm

Inv. 2379

FOR OVER A DECADE, Gulbenkian would covet this ewer, which he described as 'a superb work of art'. In 1943 its owner, Baron Henri de Rothschild, finally agreed to sell it to him. The collector had taken refuge in Portugal a year previously, as the Second World War raged. Like so many other pieces, the ewer would join his collection, which he essentially understood as a meticulous cerebral exercise, carried out in his own mind. As soon as he had acquired it, he loaned it to the National Gallery in London, and later to the National Gallery of Art in Washington, DC. It would ultimately travel from there to Lisbon years after his death, to join, in 1969, the museum that Gulbenkian had established.

Exquisitely carved in red jasper and still polished on the inside, the magnificent, strikingly proportioned ewer is of medieval origin, purportedly Byzantine. In the eighteenth century, a sumptuous gold mount was added as protection, itself a remarkable example of refined rococo craftsmanship. It is indeed a superb work of art, fit for kings. Nothing is known about the person who commissioned it, but they must have been someone of culture and means. History is silent on its provenance until it was mentioned as being in the possession of the 11th Duke of Hamilton, in 1862. By the same token, nothing is known of the authorship of the splendid *monture* or the specific circumstances in which the valuable original ewer was made.

Amid various advances and setbacks, art-historical criticism has proposed a French origin in the fourteenth century, and suggested that in all likelihood Meissonnier may have created the splendid goldsmithing.

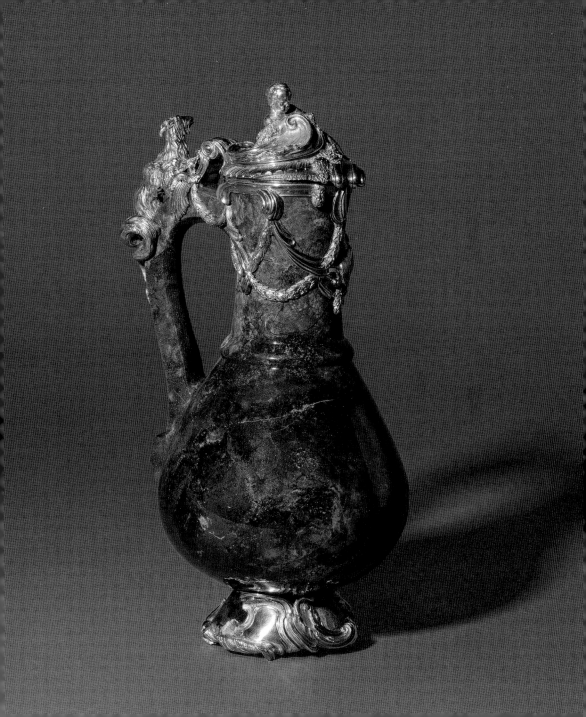

ANTOINE-SÉBASTIEN DURANT

Pair of mustard pots and case

Paris, 1750-51

Silver and gilded silver; red morocco case

Mustard pots: 16.9 × 9 × 23.9 cm; 17 × 9.2 × 23.2 cm

Case: 19.8 × 21.5 × 28.1 cm

Spoons: 1.9 × 3.3 × 12.8 cm and 1.9 × 3.3 × 13 cm

Inv. 287A/B

THIS EXQUISITE PAIR of silver mustard pots depicts two cupids, each with a wide ribbon across his shoulder, carrying a bow and pushing a wheelbarrow containing a barrel. Their original red morocco case is still preserved, adorned with the coat-of-arms of their original owner, Jeanne-Antoinette Poisson, Madame de Pompadour (1721–64). The set was purchased in 1919, by which time Calouste Gulbenkian had collected only a dozen pieces from the French School, so this was one of his first major acquisitions in the field of goldsmithing.

Their provenance was particularly appealing to the collector, who paid the significant sum of 150,000 francs for them – more than he had ever spent on such a piece. Other major factors in his decision were the unusual design, with the two cupids pushing wheelbarrows containing mustard barrels, the originality of the mechanism, which allowed them to actually roll over the table, and the fact that Germain Bapst (who wrote the information to be sent to Gulbenkian at the request of Duveen Brothers, from which he acquired them) suggested that Durant had created his cupids based on models by the sculptor Étienne Maurice Falconet.

They are accompanied by two spoons made by Éloi Guérin, a goldsmith who specialised in this type of utensil. However, the coats-of-arms engraved on the backs have been erased, making it difficult to ascertain whether they were part of the original set. This is a likely hypothesis, however, given that they are definitely contemporary pieces.

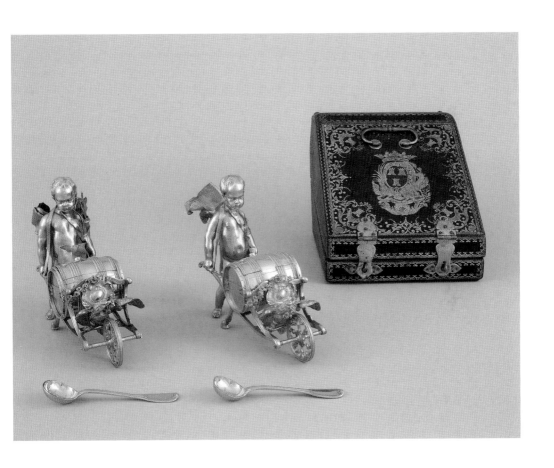

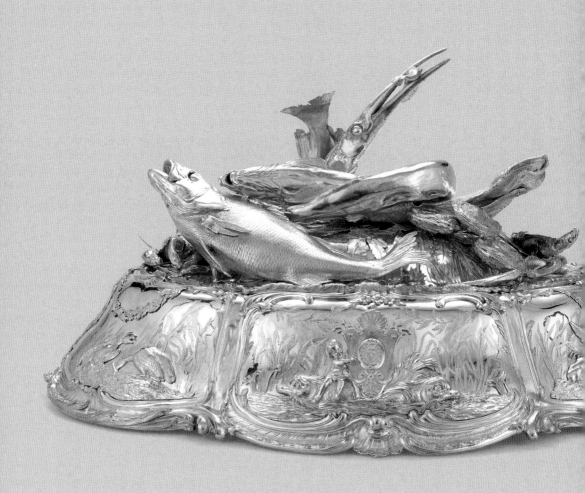

Antoine-Sébastien Durant

Cloche or dish cover
Paris, 1754-55

Silver, 28 × 58 × 45 cm

Inv. 2381

The last major piece to form part of Gulbenkian's collection of goldsmithing, Durant's extraordinary cloche represents the culmination of a collection that had attained unparalleled status among its counterparts since the remarkable acquisition of the works of François-Thomas Germain from the Hermitage Museum in 1929–30.

Some 20 years later, in 1950, Gulbenkian managed to complete it by purchasing this veritable masterpiece of French silversmithery. He wrote that he was entranced 'by the originality of its design, its architecture and its beautiful decoration'.

The piece had an irreproachable pedigree, having been commissioned by Henry Janssen, a wealthy privateer in the service of the King of France, before passing into the possession of the Counts of Eu and, later, the Duke of Penthièvre, from where it came into the possession of Louis-Philippe I, as part of the famous Penthièvre–Orléans Service. The *cloche à la matelote* (so named due to its bell shape and the fish dish that it was used to serve) is a remarkable feat of design and execution.

Technically a dish cover, or *couvre-plat*, designed to keep food warm, its impressive dimensions and extraordinary (original) weight of almost 20 kg – requiring two people to carry it – would lead some documentary sources to describe it as a centrepiece. The upper part features a prodigious still life in relief, crafted with impressive naturalism and precision, displaying fish and various kinds of shells on a watery background, amid algae and crab fishing tools.

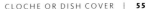

JEAN-ANTOINE HOUDON

Apollo
Paris, 1790

Bronze, 216 × 89 × 97 cm

Inv. 552

JEAN-ANTOINE HOUDON

Diana
Paris, 1780

Marble, 210 × 98 × 115 cm

Inv. 1390

TWO MAJOR WORKS OF FRENCH SCULPTURE feature in the eighteenth-century section of the Gulbenkian Collection. The first is the extraordinary *Diana*, a monumental interpretation of the theme in marble, sculpted by Houdon in 1780. It was eventually acquired by Catherine II (the Great) of Russia and, in 1930, became part of the famous lot of pieces that Gulbenkian purchased from the Soviet government. The second is the equally remarkable *Apollo*, a unique piece cast in bronze in 1790 and purchased in 1927 from Count Jean Pastré. The two sculptures were united in the atrium of Gulbenkian's Parisian mansion, echoing the circumstances of their origin: the *Apollo* had been commissioned by Girardot de Marigny in 1786 to match his *Diana* (in bronze), acquired in 1782.

Both pieces share the same sculptural mood and supremely elegant modelling. The use of a slightly larger than natural scale emphasises the boldness of the figuration and the nudity of both deities, running freely through the woods, adorned only with their divine attributes. In the case of the *Diana*, these characteristics were deemed to be 'excessive and unbecoming'. This made the piece famous and prompted the sculptor to produce a number of replicas and later versions. The transition to marble would, however, force him to create points of support – the clump of aquatic plants at the base and the quiver supporting the arm – unlike the *Apollo*, the agile figure carrying the lyre, whose activity is captured through the movement of his hair. None of this, however, detracts from the impression that these figures are advancing towards us, exposed and oblivious to the subtle eroticism that they exude.

Thomas Gainsborough

Portrait of Mrs Lowndes-Stone

England, c.1775

Oil on canvas, 232 × 153 cm

Inv. 429

This magnificent painting of imposing dimensions is considered one of Gainsborough's most beautiful portraits. Calouste Gulbenkian purchased it in 1923 for the princely sum of £37,500.00, in his most expensive deal with the firm Joseph Duveen and Partners. In his opinion, however, this Gainsborough was superior to the acclaimed *Blue Boy* – a tribute to Van Dyck – which the Californian tycoon Henry Edward Huntington had beaten him to in 1921. In 1923 Gulbenkian also bought Van Dyck's exquisite *Portrait of a Man*, which he included in his gallery.

Apparently painted on the occasion of the marriage between the subject, née Elizabeth Garth, to her cousin William Lowndes-Stone in 1775, the *Portrait of Mrs Lowndes-Stone* closely follows the model established by Van Dyck and which would become a school of art in England after the Flemish artist was appointed Principal Painter to Charles I in the 1630s. The compositional structure creates a grandiose, highly distinguished effect, with the sophisticated elegance of the elongated figure, shown full-length, standing against an idealised landscape background. Yet the informality of her pose (*au naturel*), her youthful charm, the play of transparencies in her salmon silk costume and gold-fringed gauze shawl, the use of unfinished details and the free brushstrokes, suggesting rhythm and lightness, produce an effect of spontaneity and tranquil movement. These features place it among the painter's best work and made his reputation as the 'ideal interpreter of the English woman'.

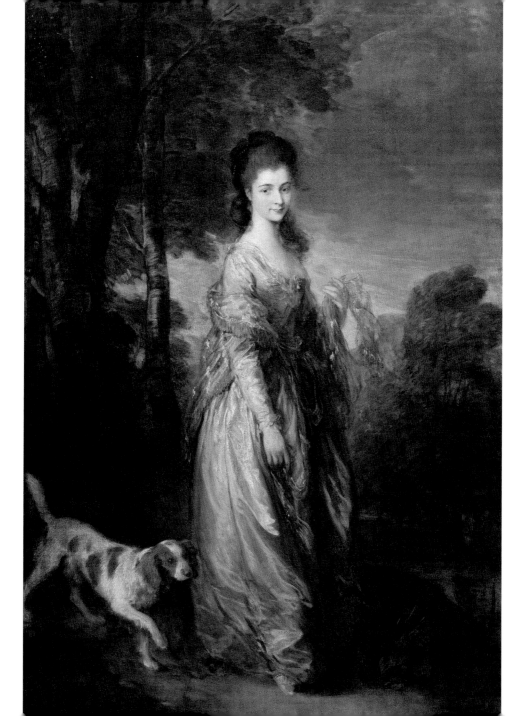

FRANCESCO GUARDI

Capriccio
Venice, *c.*1770-80

Oil on canvas, 46 × 34 cm

Inv. 531

THE SMALL CANVAS ENTITLED *Capriccio,* acquired in 1919, is one of the 19 paintings by the Venetian Francesco Guardi that Gulbenkian would accumulate between 1907 and 1921. This resulted in a unique collection that illustrates the plurality of genres to which the artist would dedicate himself. It makes an exquisite finale to the eighteenth-century art that so entranced the collector. In recent years, the Foundation has added the splendid preparatory drawing bought at Christie's in New York.

Guardi's work, with its free, spontaneous brushstrokes, exhibits 'pure pictorial instinct', setting it apart from the precise, analytical style of Canaletto or Bellotto. It vividly captures the atmosphere of faded decadence of the once splendid Venice through the diffused light, and vibrant restlessness of the blurred forms, which take shape and then disintegrate once more. The *vedute* are extensively and magnificently represented in the collection, but it is in the *capricci* (as idealised landscapes) that this set of characteristics becomes increasingly evident, as they erase the boundaries between reality and fantasy.

This piece, painted when the artist was at the height of his powers and datable (like the drawing) to around 1770/80, exemplifies these characteristics. In the poetic treatment of the double ruined arch over the watercourse and against the backdrop of the hemispherical domed temple, the artist conveys a sense of solitude and silence. He does so within the framework of a pre-romantic sensibility, with the agitated line and watercolour for the drawing, and the austere palette of greenish tones and fluid brushstrokes for the painting, dissolving the contours in a play of light and highly evocative shadows.

Francesco Guardi (1712–1795)
Capriccio with Ruined Arch and Circular Temple
Venice, *c.*1770-1780
Pen and brown ink, grey watercolours and graphite on paper
25.1 x 14.7 cm
Inv. 2871

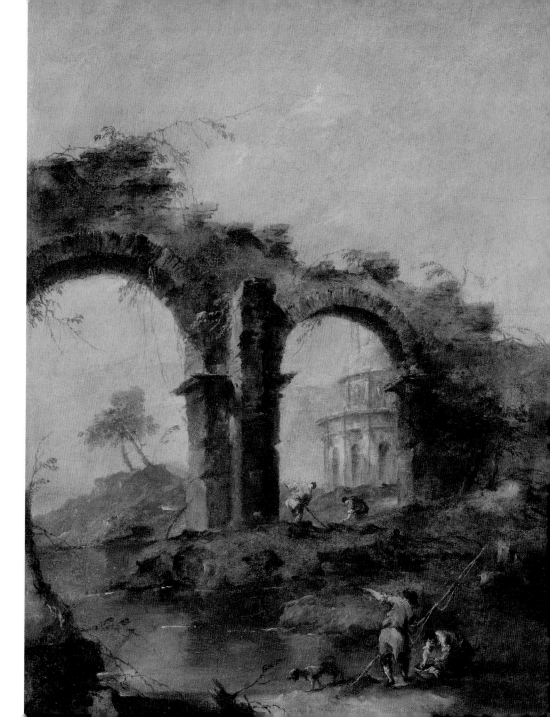

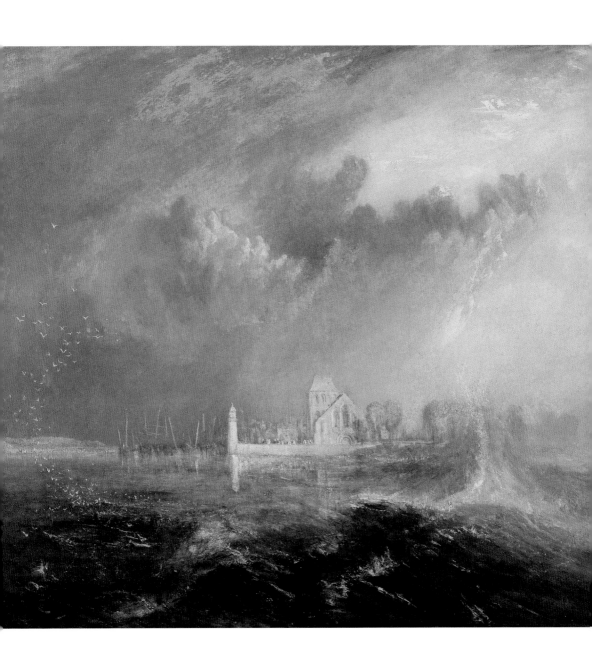

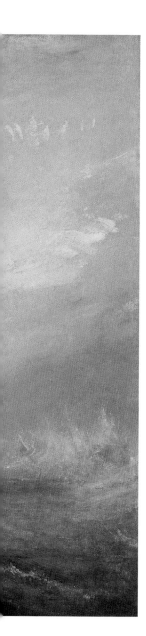

JOSEPH MALLORD WILLIAM TURNER

Quillebeuf, Mouth of the Seine
England, 1833

Oil on canvas, 88 × 120 cm

Inv. 2362

TURNER'S TRULY VISIONARY WORK opens up the nineteenth century. In the Gulbenkian Collection this is effected with three masterpieces: the beautiful watercolour *Plymouth with Rainbow* (*c.*1825); the magnificent oil painting *The Wreck of a Transport Ship* (*c.*1810); and this piece, *Quillebeuf, Mouth of the Seine* (1833), acquired in 1914, 1920 and 1946, respectively. The collector's insistence tells us a lot about his leanings in taste and his fascination with the progressive elimination of forms, to be replaced by the impressions that emerge foremost from the painter's work.

Smaller than the imposing *Wreck* (173 × 254 cm), this remarkable view of the seaside town of Quillebeuf, itself showing a theme and perspective that Turner deployed the previous year in watercolour and opaque watercolour, has all the characteristics of his finest painting. This is especially evident in the way it captures the visual and emotional possibilities of the effects generated by the disorder caused by meteorological phenomena and their overpowering impact on the fragile human condition.

Blending naturalistic observation with the sensitive recreation of reality, the dramatic impact of the representation is enhanced here by the emotive play of light and colour and by the whirlwind effect of successive circles. Under a stormy sky, the gulls' wheeling flight replicates the effect of the huge tidal bore – the *mascaret* or *barre* phenomenon which is the real theme of the composition. Faced with the fateful trinity of the church, the cemetery and the lighthouse, which dominate the scene, the dreadful drama of the shipwreck seems to dissolve amid the foam of the sea.

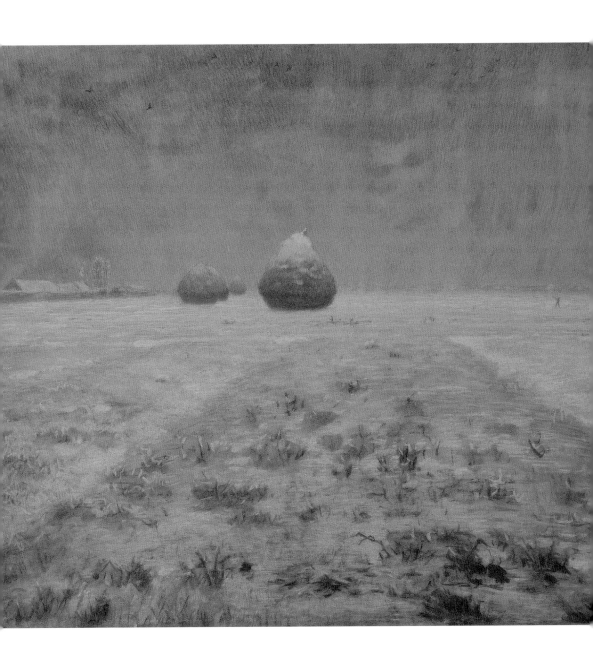

JEAN-FRANÇOIS MILLET

Winter
France, *c.*1868
Pastel, 69 × 93 cm
Inv. 89

ON 14 MAY 1920, CALOUSTE GULBENKIAN acquired two pastels from the Georges Petit Gallery in Paris. Both pieces, *Winter* and *The Rainbow* (produced slightly later, *c.*1872–73), came from the Albert Cahen Collection. The two pieces were studies for a cycle depicting the four seasons commissioned by Frédéric Hartmann. *The Rainbow* led to *Spring* (now in the Musée d'Orsay, Paris), but *Winter* never led to a final painting. A few years earlier, in late 1915, Gulbenkian had made his first purchase of a Millet, *Landscape at Dusk* (*c.*1851–52), a small but exquisite drawing that is almost an abstract vision of the bare forest, devoid of human presence, which is otherwise so important in the artist's vast *oeuvre*.

In the two pastels, however, the human touch, although blurred into the natural landscape, indicates the relationship between man and the environment that was so essential to Millet. It appears as an almost impressionistic suggestion in *The Rainbow* and is diluted in the icy vastness in *Winter*, in which the distant horizon helps to remove any sense of limits. This set of works is part of Millet's 'return to the countryside' when he relocated to Barbizon in 1849 and felt himself to be coming back home. *Winter* marks a clear peak in the artist's output. In an austere, almost monochrome palette, he strikingly captures a grey, inhospitable and hostile world where humans cannot thrive, creating an immense, silent space that is almost tangible, while the dense interplay of vanishing lines conjures the crushing, glacial feel of this desolate world.

ÉDOUARD MANET

Boy Blowing Bubbles
France, 1867

Oil on canvas, 100 × 81 cm

Inv. 2361

MORE THAN 30 YEARS ELAPSED between Gulbenkian's acquisition of Manet's two paintings *Boy with Cherries* (1910) and *Boy Blowing Bubbles* (1943). During this time, Gulbenkian would consolidate the idea for his collection. He also found refuge in Lisbon from a war that was utterly meaningless to his cosmopolitan sensibilities.

Like the tragic story behind *Boy with Cherries* – the subject died young, despite his apparent joyful vitality – perhaps nothing would seem so opportune as a metaphor for the fleeting nature of life as the allegory represented by the soap bubbles. Gulbenkian's treatment of this painting reflects his distinctive approach: bought on the advice of Kenneth Clark, director of the National Gallery in London, it would remain there (with *Boy with Cherries*) before moving to the equivalent gallery in Washington, DC, in 1950, only to be sent to the museum in Lisbon years after the collector's death.

As in *Boy with Cherries*, in which Manet used symbolism to allude to the allegory of the senses through the still life of fruit, the artist used a similar neutral background here, along with the stone parapet that delimits the space of the composition. This serves as a visual tribute to ancient painting, akin to the formal genealogy that seems to inform the theme of the soap bubbles. Executed in a free, direct style – more realist than impressionist – the composition eschews anecdotal sentimentality, focusing instead on essential pictorial values through simplified forms and abrupt combinations of light and shadow, making it a standout piece in the Gulbenkian Collection.

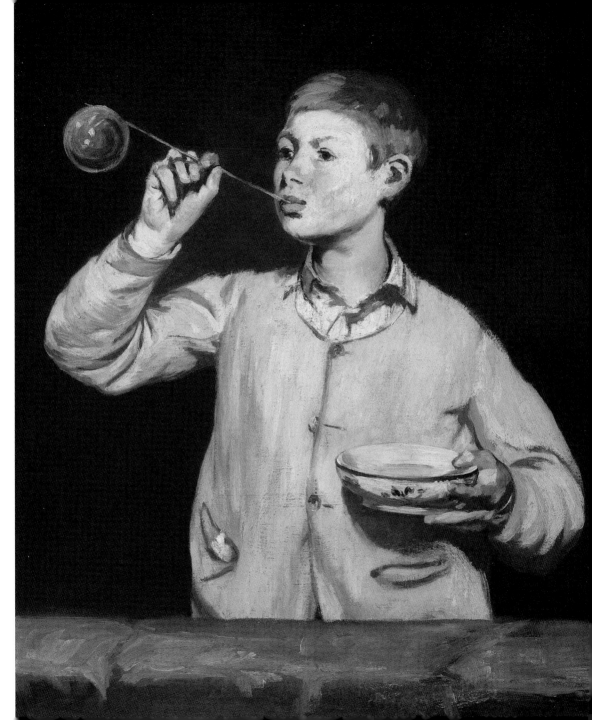

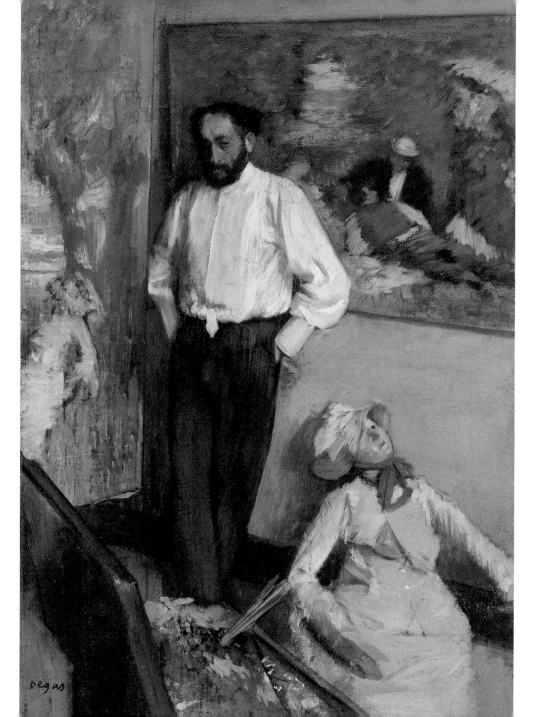

Edgar Degas

Portrait of Henri Michel-Levy

France, *c.*1878

Oil on canvas, 40 × 28 cm

Inv. 420

GULBENKIAN ADDED TWO IMPORTANT paintings by Degas to his impres-
sionist collection. Neither of them are related to the ballet themes that
would make the artist so popular, but rather to the portrait, a type of work
that obsessed Gulbenkian to the point of becoming ubiquitous across the
collection. In 1937 he acquired *Degas saluant*, one of only two half-body
self-portraits by the artist (the other is in the Musée d'Orsay in Paris).
Since 1919, however, he had owned this remarkable *Portrait of Henri
Michel-Lévy* (a minor painter and friend of Degas), made 15 years after the
self-portrait.

With a remarkable feel for staging, Degas has fashioned the small
painting from an unusually extensive panoply of motifs, combined to
create a feeling of discomfort. The effect is a sage allegory of the pain-
ful loneliness imposed by creativity. The asymmetrical composition is
structured in the manner of Japanese prints, where all the shapes are
cut and deliberately incomplete, from the paintings in the background
to the semi-covered subject, the abandoned mannequin, which turns
its back on him, and the paint box in the foreground, open like a coffin.
Everything converges to create dramatic tension.

For someone who was interested, in his own words, in 'fictitious life'
and took pleasure in bright settings and placing groups outdoors, bathed
in sunshine, this portrait of the artist in the silent prison of his studio is
especially arresting. This 'imitation of an imitation of reality' is a highly
original interpretation of the relationship between truth and illusion,
executed by a relentless, lucid observer of reality.

JOHN SINGER SARGENT

Lady and Child Asleep in a Punt under the Willows
England, 1887

Oil on canvas, 56 × 68.6 cm

Inv. 73

DESPITE HIS REPUTATION AS AN EXCELLENT portrait painter and the importance that Gulbenkian attached to the portrait as an art form, it was through this charming work, purchased by the collector in 1921, that John Singer Sargent came to be represented in the collection. Sargent was essentially an expatriate, born in Florence but of American origin. A close friend of Claude Monet, he would play a central role in the development of the impressionist movement in Great Britain through his participation in the exhibition organised in 1886 at the New English Art Club, alongside other young artists returning from Paris. In doing so, he broke with the traditional mores of academia and opted for a new form of expression, which he developed in parallel with portraiture.

He developed this approach further from the second half of the 1880s, following a stay at Monet's house in Giverny. *Lady and Child Asleep in a Punt under the Willows* was probably painted in Henley-on-Thames, west of London, following an invitation from Sargent's friends Robert and Helen Harrison to spend a season in Wargrave in the summer of 1887.

Possibly inspired by *La Barque*, a contemporary work by Monet (at the Musée Marmottan, Paris), this painting depicts two figures asleep in the torpor of a hot afternoon, shaded by the branches, and a languid feeling of *dolce far niente*. Sargent would return to this subject several times in works produced in the summers of 1887, 1888 and 1889, all in the same markedly impressionist style, both in the treatment of light and in the rapid comma-shaped brushstrokes.

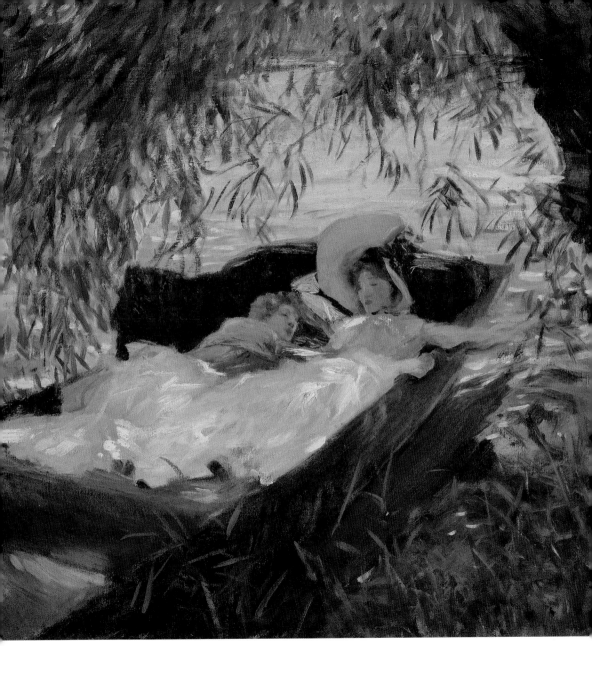

AUGUSTE RODIN

Jean d'Aire, Burgher of Calais
France, 1913

Bronze, 207 × 74 × 68 cm

Inv. 567

RODIN WAS UNDOUBTEDLY ONE OF Gulbenkian's most favoured contemporary artists; the collector acquired an unusual number of works in bronze and marble by the sculptor in the second decade of the twentieth century, either directly or, more often, through intermediaries. Of these works, the one depicting Jean d'Aire is notable for its sheer magnificence. It is a separate entity from the famous monument illustrating the Burghers of Calais, made between 1884 and 1895. The piece commemorates the famous episode in the Hundred Years War recounted by Froissart, in which a group of six of the city's most illustrious citizens were willing to suffer death in order to free it from the siege imposed by Edward III of England. Jean d'Aire (the second figure) carried the keys to the city in a mournful procession that could well have led to the scaffold.

In this monument, Rodin's art took a revolutionary step by removing the barriers between the viewer and emphasising the profound humanity of this group, whose poignant image reflects feelings that range from solidarity to loneliness, despair to revolt. To amplify the emotional impact of the depiction, the sculptor draws maximum expressiveness from clothing, muscles, feet and hands. Jean d'Aire wears his tunic like a badge of honour and wields the keys in his huge hands, but it is in his face and his determined expression that his strength and dignity are most eloquently expressed.

Of all his figures, Rodin made the greatest number of versions of this one. The one in Lisbon, bought by Gulbenkian in 1918, would be the version that the sculptor reserved for himself.

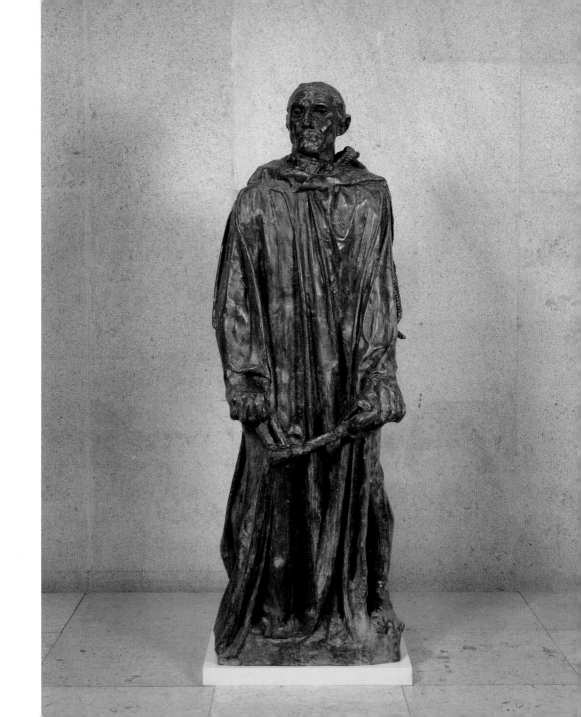

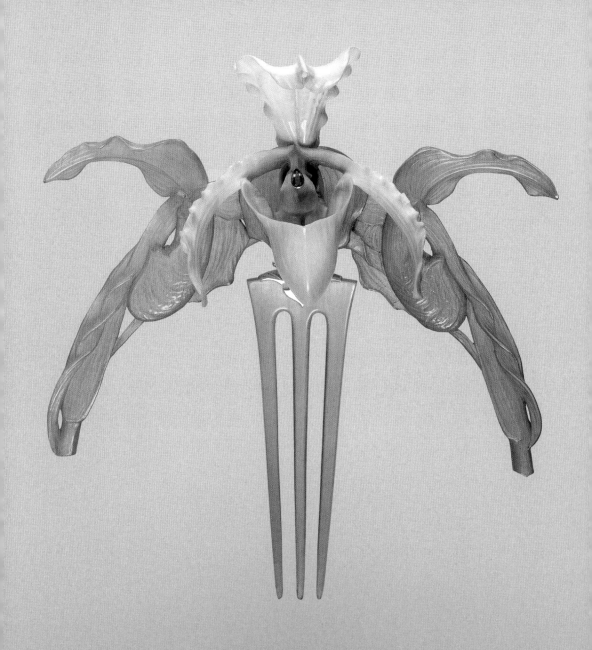

RENÉ LALIQUE

'Orchids' diadem

France, *c*.1903-04

Ivory, horn, gold and citrine, 14.5 × 16 cm

Inv. 1211

GULBENKIAN'S FRIENDSHIP WITH LALIQUE gave his works a unique status in Gulbenkian's life story and the composition of the collection. After the artist's death in 1945, the collector said, 'My admiration for his unique work grew and grew over the course of our 50-year friendship ... I am proud to have in my possession what I believe to be the largest existing set of his works, and they occupy a privileged place in my collections.'

Indeed, between 1899 and 1927, covering an aesthetic arc ranging from art nouveau to art deco, he assembled an impressive collection of 186 pieces, almost all acquired directly from the artist himself – a new and significant development. Some 82 of these pieces are jewellery, most of them unique. They illustrate Lalique's remarkable creativity and the revolution he represented in the world of Western art nouveau jewellery, mixing textures and materials in an unprecedented way.

This superb diadem, bought soon after its creation in 1904, illustrates *par excellence* the impressive realism achieved by Lalique in the treatment of the orchid, which was considered the symbolic flower of art nouveau for its voluptuousness and strong erotic associations. Almost entirely made of horn – a highly unusual choice of material – it represents three orchids, symmetrically arranged, using ivory only in the central flower and gold only in the hinge that joins it to the comb, with a single citrine gem, a semi-precious stone, simulating a drop on the main orchid.

RENÉ LALIQUE

Study for 'peacock' corsage ornament
France, *c.*1898-1900
Pencil, Indian ink and gouache on paper, 21.7 × 28.1 cm
Inv. 2471

THE PEACOCK WAS A PARTICULARLY POPULAR theme in the art nouveau movement. A number of artists were fascinated by the visual potential of the bird's exuberant plumage and iridescent colours. This exquisite bird inspired several creations by René Lalique, including this imposing corsage ornament made of enamelled gold, set with diamonds and cabochon opals. It was exhibited for the first time to great acclaim at the 1900 Exposition Universelle in Paris, and acquired by Gulbenkian later that same year.

Like an extravagant bow, the corsage ornament depicts a peacock in white enamel, turned to the right, seeming to abruptly move its tail. In doing so, it fans out its iridescent green and blue feathers symmetrically, on either side. Its eyes are oval opals (a gem that Lalique would make fashionable again), while diamonds heighten the impression of sinuous movement at the edges of the piece.

René Lalique was a gifted draughtsman, and during his most intensive period of jewellery production between 1895 to 1905 he created numerous studies for his pieces, illustrating the complexity of his creative process. Most of these would remain in his family's possession, but Gulbenkian acquired about 20, relating to works that he had bought, ornaments belonging to other collectors, or even pieces of unknown execution. In this study for the magnificent corsage ornament, the absence of the diamond bands, which would have enhanced the final work, illustrates its relevance in understanding the artist's working process.

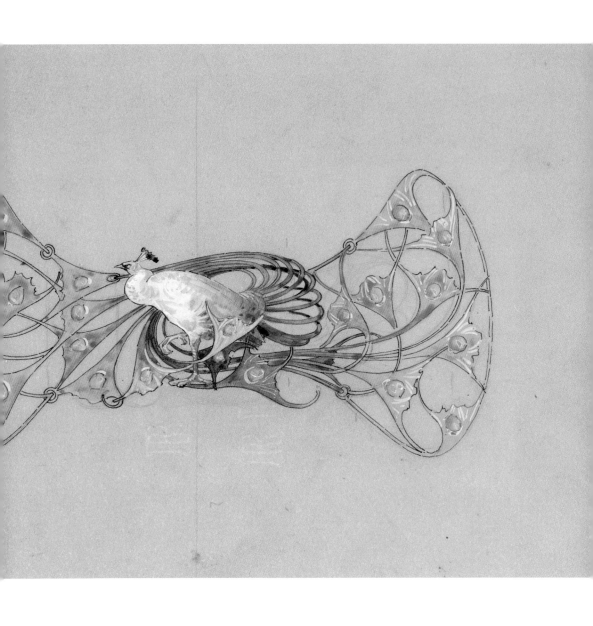

STUDY FOR 'PEACOCK' CORSAGE ORNAMENT | **77**

RENÉ LALIQUE

'Female figure' centrepiece
France, *c.*1903–05
Silver and moulded glass, 58.5 × 65 × 99 cm
Inv. 1214

GULBENKIAN BOUGHT HIS FIRST PIECE of jewellery by Lalique in 1899, when he was just 30 years old. From that point onwards and over the next three decades he would acquire a truly unique collection, including glassware and decorative objects. This imposing centrepiece, acquired in 1903, is a superb example, combining goldsmithery and the art of glassmaking.

The figure of a voluptuous naked woman, her body wrapped in seaweed that merges with her own hair, emerges from a water lily in the centre of a large bowl. This surface depicts a lily-covered lake, from the edge of which rise four female torsos, holding fish that gush water into their shared base.

The workmanship of the silver and opalescent glass makes for a convincing trompe l'oeil effect, in a remarkable feat of technique and design. In general, however, the representation of water and aquatic settings is a constant in the artist's work, not least in his 'landscape jewellery'. The female figure is also omnipresent in almost every type of object and in the collection itself. This kind of piece, where nature is simulated within a framework of literary, symbolist evocations, intertwining erudite references to classical mythology with European refinement, all projected towards a hedonistic, sensual milieu, would certainly have pleased Gulbenkian and led to Lalique's special status as an artist within his collection.

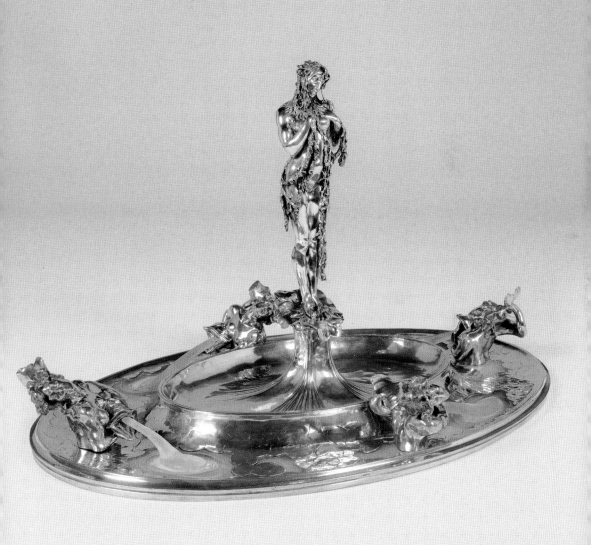

This edition © Scala Arts & Heritage Publishers Ltd, 2023
Text © Calouste Gulbenkian Museum, 2023
Photography © Calouste Gulbenkian Museum, except for Pedro Pina (p. 4) and
Pedro Matos Soares (back cover flap).

First edition published in 2023 by Scala Arts & Heritage Publishers Ltd
43 Great Ormond Street, London WC1N 3HZ, United Kingdom
www.scalapublishers.com

In association with the Calouste Gulbenkian Museum
Avenida de Berna, 45ª, 1067-001 Lisbon, Portugal
gulbenkian.pt

ISBN: 978-1-78551-421-0

Calouste Gulbenkian Museum
Editors: Carla Paulino and Rosário Azevedo
Photographic archive: Marta Areia

Project Editor: Bethany Holmes
Designer: Heather Bowen
Translation from Portuguese: Maisie Musgrave in association with
First Edition Translations Ltd, Cambridge, United Kingdom.
Editing, typesetting and proofreading in association with
First Edition Translations Ltd, Cambridge, United Kingdom.
Printed in Turkey
10 9 8 7 6 5 4 3 2 1

FRONTISPIECE:
Joseph Mallord William Turner,
Quillebeuf, Mouth of the Seine,
England, 1833, inv. 2562

COVER:
Domenico Ghirlandaio, *Portrait
of a Young Woman*, Florence,
c.1485, inv. 282

BACK COVER:
René Lalique, *Study for the
'peacock' corsage ornament*,
France, c.1898–1900, inv. 2471